DOLL STUDIES: FORENSICS

OLL STUDIES: FORENSICS

poems

Carol Guess

Black Lawrence Press

BLACK LAWRENCE PRESS
An imprint of Dzanc Books.

www.blacklawrencepress.com

Executive Editor: Diane Goettel
Book design: Steven Seighman

ISBN: 978-1-936873-16-6

First edition: January 2012

Printed in the United States of America

10 9 8 7 6 5 4 3 2 1

She was close, she was verging on something, she might have even caught a glimpse of herself in the miniature deaths, but she hesitated, took a step backward, and regained composure.

—Corinne May Botz, "Killing The Angel In The House:
The Case Of Frances Glessner Lee"

CONTENTS

Acknowledgments

Selections from this manuscript appeared as a chapbook from Dancing Girl Press.

"Box Factory," "Longing Of The Bullet For The Log In Which It's Lodged," and "Tribe Of The Uneasy" appeared in *Arch Literary Journal*.

"Littleton, Now Bethlehem," "When Dolls Love Dolls," and "Carpenters Dream of Folding Doors" appeared in *Sawbuck*.

"The Tilted Knot" appeared in *A Face to Meet the Faces: An Anthology of Contemporary Persona Poetry*.

"Troubleton" appeared in *Sixth Finch*.

"Tribe Of The Uneasy" was inspired by Jennifer Borges Foster's collaborative art event "Uneasy Heavens Await Those Fleeing."

The front cover photograph is "Attic (feet)" from the series The Nutshell Studies of Unexplained Death, 2004. I'm deeply grateful to Corinne May Botz for allowing Black Lawrence Press to reproduce her photograph.

Thanks to Western Washington University for professional leave; special thanks to Bruce Beasley, Oliver de la Paz, Marc Geisler, and Suzanne Paola. My gratitude to Kristy Bowen for her way with words and design. Thanks to Elizabeth Colen and

Emily Kendal Frey for comments; and to Geoff Bouvier, Bruce Goldfarb, Andrew Grace, Lisa Olstein, and Allison Benis White.

Thanks to my family and friends, especially Alison Fitton, Mary Ann Graflund, Gerry Guess, Kim Guess, Kerry Regan, and Debra Salazar. My gratitude to all at Bellingham Bikram Yoga.

Thanks to everyone at Black Lawrence Press and Dzanc Books, including Kit Frick, Yvonne Garrett, Lily Ladewig, Angela Leroux-Lindsey, and Kent Leatham. Special thanks to my wonderful editor, Diane Goettel, for her faith in this book.

My deepest thanks go to Corinne May Botz, whose photographs, essays, and research were my inspiration. I'm also grateful to Frances Glessner Lee, creator of The Nutshell Studies of Unexplained Death. These two women were my muses for this book.

This book is dedicated to Elizabeth Colen and to the memory of my father, Dr. Harry A. Guess.

NE: THE DENTAL ARCADE

Aerial Rifle

Here's the dollhouse wife asleep, night's chores finished in miniature. What hangs above the infant's head is red. I mean the way graffiti moves through trains, signaling who's been and when. Her husband sleeps beside her on the floor. This dollhouse lesson has to do with time. I mean the way sound travels through a house asleep. Detectives learn to sweep a story clockwise for detail. Anyone might own a gun. Pink slippers run in place atop a popcorn rug.

Late White

Tuesday detains her among beautiful dresses. She lives in the closet now, sprawl study in beaded slippers and bangles. We don't know what she charged for sex. It's easier to describe a flowered dress. You would like for there to be a rose and there is, in the papered room. Above her headboard hangs a moose. A woman found this woman dead. Each might take the other's place, bonbons in a ruffled box. Merlot coats the glass as it dries, diminishing, as one who leaves a party leaves the conversation stained.

Cottage On The Rocks Estate

Hanging from a twisted cord, this painting brings outside indoors. Through the wall we move as ghosts to pass a cottage flanked by birch. Sometimes we take too long to leave the house. When outside comes in there may be a disruption. Knick-knacks squat atop the mantle, red the color of our lips and nails, red the color of the twisted cord. This painting scares us. Take it down.

Parsonage Parlor: Girl With Meat

Set the meat beside the money. Let the piano choose its tune, and the calendar its date. Music knows something about the room that you don't. Later, strangers will reuse the chair, ash in the crook of a splintered log. Such cases often go unsolved. Girls get lost in rooms like these, mothers waiting by the tangled cord. Late light butters the flowerbox. A Biedermeier door spills men into the room.

Longing Of The Bullet For The Log In Which It's Lodged

Marian sped to report Arthur's death, ash in her hair and
blood on her dress. Cut away tarpaper. Search for days among
sticks and moss. She dropped her purse and moved the gun.
He was ending their affair, wife doused in chenille. When
lovers quarrel, objects cringe. Although HY-DA-WAY Cabin is
equipped with a bunk, we don't know where the couple fucked.
She says he lit a cigarette, and out of nowhere came a gun.
The bullet tore straight through him to the roof. Who fired at
twigs, embedding the clue? Detectives missed it among burlap
and snowshoes.

The Double Doll

Frank Harris gets two dolls. Why's he so special? He's sleeping on cement. Beside him in a cell tomorrow's Frank lies dead. Between breathing and dying Frank loses his cap. Dock Street's suspended, waiting for Harvard's pennant. Longshoremen practice stevedore lashing, binding Boston's barrels to barges. Things fall from the sky every day without warning. What struck from above left no trace of blood. Frank returned to stopper knots, no time to nurse a bump on the head. Who doesn't see stars dockside at night on a clandestine run to dump dunnage off deck? Two Franks aligned shims and hoisted rope: visible docker and invisible corpse.

Box Factory

Spatter tells a story best read by day, headline array and angles.
Blue bedroom boxmaker, what have you done with your
drunken rifle? Someone wore your suit before she lent it to
the dead. A beaded lamp tints tabloid gossip. Who crumpled
Screenland on the sill? Fruit bruises the bowl, clueless as your
upturned chair. Your wife's lying, string round her ring finger,
trigger or vow. All hail King Cardboard, whose henchmen won't
miss you. Strop waits for stubble, saint on a nail.

Tribe Of The Uneasy

Past No Name Slough you flee on foot, balancing dread with the dead weight of days that never open to dance halls. Rust dogs the rails. Brick walls with wire scars skirt stretches of random. The squirrel on the curb is loam. Too many blankets keep winter away, enough to nix chatter and stifle work's whistle. Beside you, someone rehearses your death, as close to married as you'll ever get.

Flint And Steel

Charred wood splices evenfall, spire or star. The soot-stained
bed sideswipes the dresser. Left for luck, then luck departs.
You're flint fleeing tenderness. Do your little totentanz among
the emerald scrim. Back home your uncle's bones burn down.
Bread you kneaded dries uneaten. You live in the forest now,
among the owls. You've no concern for gasoline whorls.
Detectives place bets on the dental arcade.

Kicks

You're going to kill her. At least give her legs. She's drinking from a shard of glass, bloomers cycling in rigor mortis. Pink garters chasten knitted stockings. A cake of soap pines for her dirt. Sauced on gin, perhaps she slipped. Stiff legs suggest she stiffened elsewhere. Dinner tasted of its tinfoil cover. Wainscoting grasps the tub in its fist. Gentlemen friends brought gin to her room, but somehow *Dark Bathroom* is the scene of the crime. She's open-ended. You can see up her skirt. No doubt she's finished to the last doll part. She's swimming upside-down in flounces, drunk on water, the last thing she'll taste. She'll never listen to Sousa's opus. *Plessy v. Ferguson* upholds the law.

American Linden

Beer and a Bible flank the Jenny Lind bed. An unopened box bleeds clues on the dresser. His walls crawl with flowers. They'll bury him if he's not careful. His wife's a lovely girl who just happens to be somewhere else. RISD students painted doll beds for cash, *Tilia americana*, 1/32nd of an inch. Each TynieToy clock reads 10:15. The dishpan doesn't belong by the bed.

Carpenters Dream Of Folding Doors

Late auto, and a death in the garage. Gray hat at the center
of a concrete star. Lee rehearsed with a human, recording his
sprawl to determine the placement of the victimized doll. When
affection dissolves, husbands ride off. How to leave home is
often a concern. Brick-by-brick his wife walled this one in to
risk the wild engine and the poker's swing.

Rural Picaresque

These fields have ruined better farmers than Eben. Ignore
his sway, his bloated features. It's double indemnity if he was
bluffing, soles surprised by a crack in the crate. Hay housed a
spider, widowed when she spun off-scale. Pretend his body isn't
there.

Girl On Wheels

Her story begins with Seconal. Her husband did it, another
doll. She kicked off her heels by a borrowed bed. Pin-ups dodge
the date by years. The bed's on wheels. The missing man might
come to call when light dissolves on concrete lawns. The idea
is not to solve the crime. Color and texture form the prelude to
meaning. The idea is to see as at a museum. Kisses on a pillow
give the crime away.

Cake, With Corpse

The kitchen's perfection belies its weapon. Gas jets open as
wrists in a tub, filling me with peace because I'm only watching.
I stand above the diorama, magnifying glass to scene. Castles
paper cardboard walls, a story not in words but things.
Housewife sprawls, stiff-limbed in skirt. There should be a
mouse, at least. How holy a quiet house. A week's worth of
letters curl beneath the door's bronze mouth.

Soot Tells A Story To The Throat

Nothing grows but speculation. There won't be a coffin, just a clandestine dig. Rags, gasoline, and a boy running feral through the yard to the woods to the road out of town. No ash outlines absence. No watch, no ring. Just dinner, half-eaten. Fuel jug askew. Mirror devoured by the blowtorch used to burn a cabin carved to be burned. Why stitch a man who won't be found? The missing doll was never crafted. We need him, the god who just disappears.

TWO: SO DIRTY, SO FAST

Littleton, Now Bethlehem

The cabin was ours all winter. You paid for this, the sleek word
mistress. I touched the gun because the gun touched you. I
swear I didn't do it, although your hair was something I could
have. While you were sleeping I cut it, true. If they search
my house they'll find you in boxes, sweaters that smell of the
way you walked. The shot came from behind. I heard her sigh
into the job. Your wife had insurance; she made sure of that.
Last to see you, I'm under suspicion. My prints aren't on the
ammunition.

Alabi Involving Deer

What I wrapped for you was bleeding. Animals don't speak, which is why I prefer them. Your mother's gaze suggests I did it. I'm the last link to your whereabouts, but my apron bleeds venison. I've sliced hundreds of thighs. What works for me puts up a struggle. What works for me might win. You were too easy a target in your schoolgirl whites, red ribboned hair. You were snow in August, Dorothy. I'm not beckoned by the cold. Mrs. Dennison will have to get used to it, mothering what you are to her now. They'll bury you under a gauze of green lawn. She'll learn to accept that the herd moves on.

Indoor Army of My Own Design

See to it that I dream of machines. Prints point out instead of in. Cars become islands, become people driving, become people stealing, steel for skin. My wife's lovely, coin toss guessed correctly. But toss again, and her face disappears. You think I'm strange, but she's the strange one, filled with rage and gasoline.

PERSONAL ATTENTION MRS. MARIAN CHASE

MARIAN STOP MY WIFE KNOWS STOP FOUND LETTERS STOP FALSE BOTTOM DRAWER She'd never snooped before; perhaps she dropped an earring or a dime. Felt the crease between two seams. This isn't how I WANT TO LOVE YOU, raw and on the run like thieves. Wild animals MEET AT THE HY-DA-WAY, too. BRING SUITCASE I'll take my time with you in the hotel. Then perhaps new names, new city. Are you sure of me, darling? Is this what you want? Divorce is costly, but you're worth rubies. BRING Gloves and an Umbrella, as the forecast sigNals rain.

When Dolls Love Dolls

I found her; what does that make me? And not to touch. And
not to see the bloated body. Believe me when I tell you what I
gave her was enough. She asked for shiny, so I spit on my shoes.
Worked double shifts fixing snafus on conveyers. Why didn't
she speak for hours after church? Nights, I curled into her
back to dream, but when I turned she left me cold. Once she
called me John. I'm Fred. I don't know why she wanted freckled
reindeer on the wall.

The Lieutenant's Wife Keeps Dinner Warm

Lettuce hangs its head in the icebox. Ice cream melts, sweet
rotten teeth. Decipher the steam from my pots and learn how
pure I am, and neat. This isn't a lullaby but facts stacked like
dishes. The victim's name changes; there's a range of ages. Don't
lead me past quaking aspen. Don't show me the culvert where
you found the girl, chalkmark faint as the vein in your neck
when you worry the sheets, tense fabric you tear in your sleep,
talking to dead girls, their arms around your neck, Love—

The Tilted Knot

Widowed both, when we finished sitting shiva we shared shy
glances at Central Synagogue. I thought of her more than I
should have, I know. They say the guilty return to the scene,
but what of the innocent? For a time I stood accused because
of my access to Rose Fishman's room. For thirty years I've
cleaned apartments on Hester and Essex. Now all I see is that
fishbowl room, bottles of perfume, pink towels askew. I found
her strangled with her bathrobe belt. Thought I'd go to jail until
a cop paused at the knot. Tilted up, as if she'd hung. Threads on
the door where her garment was torn.

Delectable Mountain, Wandering Foot

Death came for me and missed, aiming below a dozen
patchwork quilts. On Sundays, church families from High Field
Village distribute handouts round our camp. It was Wilby's
idea to keep going back. She said they'd never learn our faces.
Twelve quilts later the temperature dropped. Carl covered her;
we thought she'd love the weight of heat. Not knowing she was
dead, I kissed green flowers stitched into a square. Tomorrow
I'll swing my axe all day, wood for their stoves, their tables and
chairs.

Pastoral, With Noose

Hunger was a problem I thought I could solve. It isn't true that farmers want a world where nothing happens. I know the city birds know, violence and passion amid bracken. I never asked buildings to bend to my plow. When the human city came for my farm it came for the land, not the land's bounty. What good is a horse compared to a car? Fat rubber legs run so dirty, so fast. I swear the blight looked beautiful at first: *Alternaria*, stippled like a Hoover flag.

Headline Red

Lipstick loses face fast slashed on the sash of one wet wrist.
Kisses and whiskey: I thought Marie missed me. My step on the
stair. My razors and foam. She brought me home for what—to
wait? A date with a suitcase fat with excuses. Prissy this and
dizzy that. She put up a fight with fists, and bit. The most
dangerous knives are dull. No matter;
I win what I want one way or another.

Ruffian

Roughed up, ruff at the throat, spies in the collar of my uncle's coat. You think I'm listening, but I'm taking notes. You think I'm blind, but I'm King of the Bees. Hear them humming in the soffit's sleeve.

Stray Bullet Boys

Jack

Stan needs more muscle. Dad bought a .22, said do the kid a favor, boy. Teach him what don't come from school. We aim at crows; I never miss, but Stan's fire swings an ugly arc. Mom packs loaf and sweets in tins. I eat mine and half of his. Nights he tutors me, Math and History. When Harlan punches him at lunch, I make the girls kiss me to watch.

Stanley

Jack's all swagger and cigarettes. I don't know why he pals with me, though in the woods I think I do. He's teaching me to shoot. Learned sharp aim from downing birds, but in the woods he seems unsure. Like a girl I say his name and like a slap he says forget. Someday I'll find a brighter city, lights that never miss their mark. Look up, Jack says, aim past the porch.

Troubleton

I went looking for trouble so I stood behind you in a
haberdasher's with a picture window with your pocket watch
with your gray fedora flyboy stance sharpshooter's name shame
on us sweet startled water after walking the length of the city
in summer I went looking for heat instead I found trouble with
your southern twang like my long-ago lover and who would I be
and would she be with me if I'd stayed in that town dust on my
shoes?

Reapers

We mimicked horses in the winnowed field. I was the giant eye.
You were the throat that whinnied. We never went back—not
for night call or nightcap. Widowed to each other, we walked
the perimeter in search of riders. Giddy up blinders. Bats hung
upside-down from rafters. The weathervane twisted the barn
owl's mane. Inside the mess of wood and hay, horseshoes held
out for the herd. Down Brindle Road we took turns posting: one
the bridle, one the whip. The dead need collecting and we were
collectors. We carried last words down dustbone roads.

DRexel-6

Moments of freedom from Mother undo me. Gloves unravel
thread by thread. A summer tantrum scatters newsprint. I kick
a restless path toward Elm. Here's where I crouch, not to peer
but to patch my hem. It's true there's skittish gossip rattling
shopfronts and me. Party lines tip and ring in fits. I'm my own
best acrobat, turning one-handed cartwheels into works of art.
Father's waiting, belting warnings. My shipwreck wrists chafe
at the knot. If they knew about LAwrence, they'd bind me to
breakfast: lashed to one table for the rest of my life.

The Case Of The Seductive Secretary

Shakedown, starring Della Street. 120 words per minute, Boss: you love my speed. No alphabetarian. No abecedarian. No two-finger typist, all hunt and peck. Husband material admires firm posture. Short skirts work; bending works better. Dozens of hats, tied with typewriter ribbon. I'm all woman, and halfway fiction. When Mr. Gardner penned a mystery for Frances Lee, I wasn't green. Fanny sported suits and ties. Stood broad-shouldered in the vestibule when I hung his coat, so I hung hers, too.

Annals Of Dolls Ill-Formed

Not every doll looks fine enough to die. Sometimes the scissors slip her shoulders. Her clavicle caves, her neck dangles. Off with her head and onto the pile. I died once, in a flurry of tulle. *Dance Hall Follies*, the scene was called. Nettie McQuiddick poisoned my whiskey. Mid-pirouette I slumped to the floor. There's pride in trying; we're evidence of that. Mother's demanding, fashioning stockings for every corpse, tinting each face to suggest mode of death. With so much to do, she can't love us all equally. My siblings and I compete to be burned. Now I'm a head and left feet in a pile, unseen among rivals vying to die.

Playhouse On The Rocks Estate

Cut their throats. Hold their heads underwater until the sieve
drains clear. Seal them in the cellar for a little sun mid-winter:
what girls learn from jam. How to serve, eyes averted. How to
sweep for detail, broom sifting dust. The Rocks Estate spans a
thousand acres, but I'm schooled in miniatures. No beakers, no
chalk. College might bend me, might upend me. Splinter the
fence that stiffens my hem. While brother George trades barbs
at Harvard, I'm flanked by granite and my husband's moniker.
Blackberries bruise. Apples, too: my bee sting school.

Mirror Houses, Prairie Avenue

My brother's bricks touch mine. He lives beside me in a house
made of money. Rid of the husband, my suit skirts the nursery,
where babies sip tea and learn to say *please*. Little time bombs,
little incisions. My dolls aren't for children. I would rather dine
with men, inventing legal medicine. Who trailed an ox yoke
through the dirt? My dioramas aren't dwellings I'd dwell in.
Women bore me until they're dead.

Aviation Medicine

Down our street lived a man missing part of his body. The war kept it when he returned home, on a plane that shook when it landed. He did not kiss tarmac or his pretty wife. She was gone within a month. The man who was missing part of his body fed the birds in the birdhouse. All mouth. Every morning he stood in the field and scattered seeds. Over time the birds brought back part of his body, wings a bright limb always in motion. But the limb moved only when they moved. When they flew, the limb flew with them. What stirred in him as he leapt from our brownstone was the desire to follow his flock.

HREE: DEPARTURE LOUNGE

Departure Lounge

1.

When you returned from the war you had a secret. You hid it from others because they looked only at your mouth, too wide, and your haunted eyes. But I saw everything. I never forgot anything that passed between us. I remembered every corner of every room, every color you ever wore, and in what order. Names of streets as you rode away. Something was missing from your body. The name of the thing that was missing was a word I couldn't say. It was a word I'd erased from my vocabulary. At first I erased the letters in the word as well, but with time I re-introduced them. They seemed so dangerous, criminals among the alphabet, just waiting to re-group and form the word I couldn't say.

2.
For a time after you left I slept with your letters, a very thin person who smelled of paste.

3.

X marked the spot in the ruined field where your Superfortress
split in two. Something clung to the trees like pre-war stockings.
Wind-bitten and thorn-torn, threads bruised at the hem.
You rummaged through brush to find your officer bleeding,
parachute tangled like a sweetheart's sheets.

4.

After you left for the front, I turned to invention. I created a face to fill the hole. After you left the hole was inside me. I felt it widen, rehearsing. Things shifted, sifted through the hole. When you returned and looked through me, my skin burned away. You moved seamlessly, as you always had, while I stayed static in my haunted skin.

5.

X-rays were discovered in 1895 by Wilhelm Conrad Roentgen.
The first X-ray image of the human body was his wife's hand,
her wedding ring a smudge across ghostly bones. In the quiet of
the photograph the bones taper and release. The smear of ring
looks out instead of in. It looks away from bones and toward the
optimistic ray.

6.

Why you and not the others? My father and my little dog. My father's lungs filled with water. My little dog's heart grew too big for her chest.

7.

Ice and shiver into winter, when your face returned as snow.
I carved around it carefully and brought it into the house.
At first I thought I should keep it in the icebox, with snow
days, snowballs, and angels. After you left I thought I'd make
breakfast every Sunday. Hotcakes with blueberries. Toast dipped
in cream. But the cakes burned, and syrup stuck to my fingers.
On Sundays I slept until noon and listened to stories from the
front on the Philco. Store-bought syrup came in a jug decorated
with high-stepping horses. I slid your frozen face onto a plate. I
poured syrup into the crevices of your snowcake, and ate.

8.

I dreamed of crashing into trees with bone-white trunks and X-ray leaves.

9.

Crows went crazy guarding crow babies. Something raw in the heart of the city. The things we knew we tore apart to know again. It shouldn't have surprised me that you came back in pieces: your face at our window; your legs climbing hills in a city of coffin corners. You told me once that randomness didn't suit me. My deliberate ways pleased you. My patterns. Now only the field, and the crows, and the mice, who slept when I slept, and took care of themselves.

10.

Lightning shook the house by its scruff. This wasn't a sign of your return, nor of your departure, but a sign that I'd thought the unthinkable simply by thinking of your body. Your blood, moving from heart to extremities. Your fingertips flushed pink, spotted white along the nails. Your body, and the names I gave it, or rather, the names I gave the things it could do.

11.

Questions remained about the crash. The investigation hadn't gone smoothly. Maybe numbers and dials on the dashboard stopped being beautiful and instead, the field.

12.

Outside our kitchen window was a birdhouse with a painted
roof. One day a small brown bird flew into the birdhouse. The
bird tossed bits of straw and feathers out of the hole. Then it
flew around finding new bits of straw and feathers, and stuffed
those inside the hole. After several weeks a mouth appeared in
the birdhouse. The mouth stayed open all the time. Birds flew
back and forth, bringing it worms and white stuff. Sometimes
the mouth swallowed and sometimes it spit. One morning I saw
something brown in a patch of clover. The baby bird lay still,
stiff toes like twigs. Its stomach was covered in flies and its head
seemed to be missing. I thought I should throw the baby away.
Then I worried that it wasn't dead, only injured, and because
of the sun overhead and the way I was standing I couldn't see
clearly. If I tossed the bird away before it was dead I was a
murderer.

13.

I imagined the X-ray, skin falling away, bones and my ring: a hole on the screen.

14.

Open your eyes. You were inside. Perhaps you had a key. I knew I'd see your face when I opened my eyes. I knew I'd have to give your face a body, which exhausted me. It was as if I dredged your body from within me. I felt the blood leaving and the nothingness of the space it left. But if this was what I had to give you so you'd stay, I would.

15.
We stood together in the room I'd made my own after you left.
I wanted to name the face so I gave it your name. Because a
face can't hang like a moon over a river I gave it your body. The
things you'd done hung between us, numbers in quadrants like
numbers indicating color in paint-by-number boats and rivers.
The things you'd done were mathematical. The things you'd
done were problems: *XO.* We were what solved problems, but
what hung between us couldn't be solved. The body I'd given the
face moved as you moved in this new room. A bright blue chair
sat facing the window. *Too much color makes me dizzy.* This was
the first thing you said. I replied with an offer: coffee, tea. *A cool
cloth.* The face—your face—pressed the cloth to its forehead.

16.

When I woke you were gone. I could tell we'd had an earthquake
because your glass was on the floor in shards. Not smashed as if
in anger, just that thing that earthquakes do. I looked for a note
but there was no note. I looked for something to make sure I
hadn't dreamed you. Then I wondered was it bad if I'd dreamed
you. Maybe the bomb was a dream and Roswell a dream and
all of our loving and brokenness dreaming. You'd shake, and
I'd hold you to stop the shaking. Press my face into your neck
and mostly you'd stop but sometimes I'd start. When both of us
shook we were in trouble. That was when we let things slide.

17.

If I was making you up, I wasn't making you up the way I wanted. If I was making you up, there were two of me, one inventing and one desiring. The inventor made you very beautiful and very far away. The lover made you a cipher, and everything after, religion. I wondered which *I* you saw in me: the one who invented you or the one who loved you. What would you do with us both in one room? The narrow bed. Your gaze like light falling over our thighs.

18.
I closed my eyes and drew the blood in my body into a body to give to you willingly.

19.
Birds returned to the birdhouse. All mouth. This was how you looked. Full of questions. *It's only a plane. It's only a cloud.* What was your body seemed to float below your face, then become accustomed. With time your gestures synchronized. Your body took on its old, faded grace. What was graceful about you was always moving. You were a river and I watched you steal things, float them rough out of reach, high and low at once. I visited shyly, without permission, math etched into every hole.

20.

Before the war we found a nautical window beneath the pier.
The metal was scratched, but the glass was intact, a round
eye with seaweed for an iris and sandy lashes. One broken
thing about the window: it screwed shut, screws at the top and
bottom, but the bottom lock was off, and wouldn't set. A few
months later, alone in the house, I saw a hand wave from the
attic. I pressed myself against the wall, away from the criminal.
When I looked up again the hand was green and sinewy. A
long vine, leafy, had snuck in where the bottom lock wouldn't
click, fixing itself to the wall with sticky tentacles. I climbed
the ladder with a knife. You opened the door as I was climbing
down, knife and vine in one hand, the other clasping the ladder
as my stockinged feet slipped down the rungs. I thought you'd
fix the window, but you liked your woman on a ladder with a
knife and something green. The vine never returned. Instead
snow, a tender crescent beneath the swollen globe.

FOUR: LYE AND LILLIES

What Wounds Us Starts As Gifts From Strangers

The sky names its price. Her falling body barters badly. Who thinks to buy wings at a time like this? Now she's sleeping on cement. Tiers of linen storm the porch. Stray dogs visit and know more than detectives. Some blood writes a story only animals read. This case is retired because it's too hard to solve, clues tucked away, invisible metal. To undo her death you have to undress her. The icebox flashes its numbered demands.

The Philco Hour

Objects always tell the truth. A little Sherlock with *The Littleton Courier* before the wife locks down her curlers. She's downstairs, facedown on stairs inside the scrim. Stiff before the curtain rises, birds embroidered onto velvet risers. Her nightdress features crocheted trim, hinting at the corpse within. Stubbed smokes stubble sidearm tables. The telephone squats on the floor. Tone array: *bright, brilliant, mellow.* The Philco pulses with mystery control.

Bagatelle

Someone followed her this far. They'll follow her farther, *Für Elise* on piano. Whoever unlocked the door seemed gentle. Called her *Dorothy,* maybe *Dot.* Her slippers lace, red ribboned X. What of the butcher who wasted his meat? It isn't the knife or the missing button, but bite marks pocking cleavage and thighs. Maybe she's pregnant, a plausible guess. She told him she loved him, and the knife answered yes.

Last Seen

Bodies are often found elsewhere. Unraveling skeins cut a
rug in Dutch light. A locked armoire or a house like this one.
What passes the window is sensed, not seen. There's a shadow
corresponding to a hill inside the girl. A breeze where she was
last feared lost. Dust stipples armchairs, ecru to taupe. Shutters
and hooks bruise a wall of flung coats.

Adelaide, Or The Language Of Flowers

No specificity to Striped Bedroom's blooms. Where's carnation,
iris, flax? Curtains pin back their blondes with tacks. The
overhead light shoots the bed in the foot. Mother's a felt hat
posed in a pew: mandrake, milkweed, narcissus, yew. Here
comes leisure, after ice cream, dry ice tangled in bedskirts and
beer. Dick's wedding photo tilts beside a pocket watch and
Lucky Strikes. His missing wife's train runs out of the frame.

Give Yourself To The Water On The Wall

Follow the smell to the escape. Outside Mrs. Fishman's window, scan tulle curtains tied in pigtails. Through the glass she's wrapped in blue, seeping fluids. The marble tub suggests she washed. Postmarked Poland, renamed *Birch*, her father's letters slowed, then stopped. You might be cuffed, might be bloated yourself, but for blue thread tufting the lintel. Ghost fish shadow dazzling cousins. She did the best she could to hang.

Autopsy Of A Shot

There's no saving some people. They fall as they were meant to
fall, and the current carries them forever. Earth reaches up as
sky reaches down. This body's female in a roseate gown. She
aches as a child aches in its bed. Then the field, with its terrible
fortune for the boy, already written. He rubs his palm against a
rock to scrape it off. Mother's nowhere to be seen, isn't who he
wants or needs. Corn's a cipher in its green silk sheath. Risky to
cross where the whistle won't reach. Rail's end, and a door with
worn locks. Neighboring houses sleep through hard knocks.

Hatch

Who cracked the treeline like an egg, revealing a boy? Who left him alone among salal? Child stammers his first name. Follows a trail of breadcrumbs and gull bones. Invents religion and anoints himself martyr. Sets fire to the first branch that gets in his way. Downhill, flurry, postcards to Mother. *Wish you were here,* or make up an uncle. Every room he enters empties. Here's his future, charred. Here's accelerant he'll use to save himself, sleepwalker caught in night's crooked arms.

Crooked Mouth

Mother promised there'd be gardens in the apples this year.
Hands behind her back: she's lying. Hands above her head:
surrender. Sounding out letters over and over. When she stands
on her stoop, small children swarm her. She doesn't know which
of the children are hers. Fact: she's filled with milk she can't give
back. Doesn't know how to pray. Invents a master. Her hands
run away while her feet shoot roots.

Silent Delivery

What happens on the roof becomes part of the sky. Sparrows
know nothing of waking the dead. You'll never lure birds if
you stay in the sway, right angle to wire, stiff as a broom. One
shoe tips off the attic stair, clue or last kick at a passel of letters.
The milkman rubbered his hooves for quiet, horses docile as
Devonshire cream. Knitted stockings were the hardest task,
your maker's penance for leaving you lifeless. Lee knit with pins.
You kicked and kicked. A doll's doll watches while the spindle
pricks.

Post-War Hotel

What you take from her will never be enough. It isn't money
you're after. The divorce didn't last because memory is stronger
than law, and stranger. Strangers come to this room to touch,
but you killed your wife. For now she's nameless, bedposts
framing downturned face. All couples argue, but some never
stop. What's truer is that people snap. Clues collect, but you've
got to be looking. Your wife just wasn't paying attention.
Nothing about her reminds you of me.

The Awful Truth

Your hand hangs away from your body. It doesn't remember what it set out to do. Think quickly. This is an urgent matter. Aluminum skin curls off the cake. Set the skin beside the plate. Lovely appliances, gleaming and crumb-less! You know the rest of the night's events, rocker rocking in the rifle's path. Detectives, clumsy with curtains and kittens, rush to a showing of *A Day At The Races*.

Tenth Seminar In Homicide Investigation

Touch nothing. There's tenderness in looking. You become
their lips, their eyes. In the old way, police arrived first on the
scene. Fumbled clues with mud-caked boots. Lifted glasses
and punctured chocolates. Cradled the dead man's wife in
their arms. You're on the scene, but think wallflower, watching.
Attach to nothing. It's nothing like loving. Not for you to judge
or convict. The protection you offer appears prophylactic, but
your job at a crime scene is simply to see. Only newbies wallow
in sentiment, eyes averted when they meet the bereaved.

What Comes From A Body Must Bear Its Own Beauty

After everything, the rug. Cold water and salt diminish blood.
Tallow and lye exhume lilies from towels. Suds skim scum from
paper fish. Samuel spits: enzymes in saliva. Neighbors group in
the hall to gape. The sink needs washing, too, and mug. Samuel
rinses his mop in the tub.

Hard Chic

Hello is often met with no reply. One might be rolling cigarettes. One might be painting toenails red, cotton rags between each digit. One might be dead, in which case Mr. Green might need to be questioned. One's suitcase might be confiscated. Among Marie's clothes, note attention to shoulders. Exposed calves reveal inked seams. *Les sanglots longs* sent soldiers running. Marie's riots were nylon. Later, Mrs. Flanagan will scrub the rug. Rinse blood from a hem that flatters her figure. Crooning to Crosby in a floor-length mirror she'll twirl her skirt, borrowed from a corpse.

Effacé

Something's awry with the state of the body. When a dancer slides her foot in passé, the pointe mustn't snag sur le cou-de-pied. Dorothy's slippers lace up her calves. No rolling up the rug to dance. The pier table's marble. Sheets cover armchairs, protecting softness with softness from dust. I want to go back to the one who haunts me because I think I love her: girl with meat. She's littering the floor with plot. The room's a museum, girl under glass. Bare limbs stiffen, posed poise on display. The parsonage door opens onto the page.

Petitioner

Linda Mae's black rocking stallion gallops into her cradle
from a Cracker Jack box. Must you use that crimson paint?
You made us. You gave us tiny Rice Krispies. You could let us
sleep; breakfast's already set. Kate's dishrag dries on the edge of
the sink. Milk's on the porch, three creamy bottles. Soon Paul
Abbott will arrive with his car. Can't you shut the window, seal
Bob's gun inside his safe? The telephone echoes. Miniature
flashlights illuminate rescue. Can't we leave the house alive?

Notes on the Text

These poems are based on crime scene dioramas created by Frances Glessner Lee, as photographed and researched by Corinne May Botz in her book *The Nutshell Studies of Unexplained Death* (The Monacelli Press, Inc., 2004). Information about Botz's art is available on her website:

http://www.corinnebotz.com/Corinne_May_Botz/Corinne_May_Botz.html

In "American Linden," I drew on the following websites for detail:

http://tynietoy.com/site.htm
http://www.pbs.org/wgbh/roadshow/archive/200501A18.html

Information about Philco Radios was drawn from this site:

http://www.philcoradio.com/history/index.htm

The following websites provided me with useful details:

http://www.cultcase.com/2008/05/x-ray-photography-as-art-hidden-faces.html
http://www.nlm.nih.gov/visibleproofs/galleries/biographies/lee.html
http://www.historylink101.com/ww2-planes/aa-b-29-superfortress.htm
http://brucegoldfarb.com/the-nutshell-studies-of-unexplained-death

"The Awful Truth" and "A Day At The Races" were popular films in 1937. "Les sanglots longs" is the beginning of Paul Verlaine's "Chanson d'Automne." The first two lines of the poem were broadcast in 1944 by the Allies as a code signaling the French Resistance to prepare for D-Day.

Joanne Tilley

CAROL GUESS is the author of nine previous books of poetry and prose, including *Tinderbox Lawn* and *Switch*. She is Associate Professor of English at Western Washington University, and lives in Seattle.